The Art of the Pen

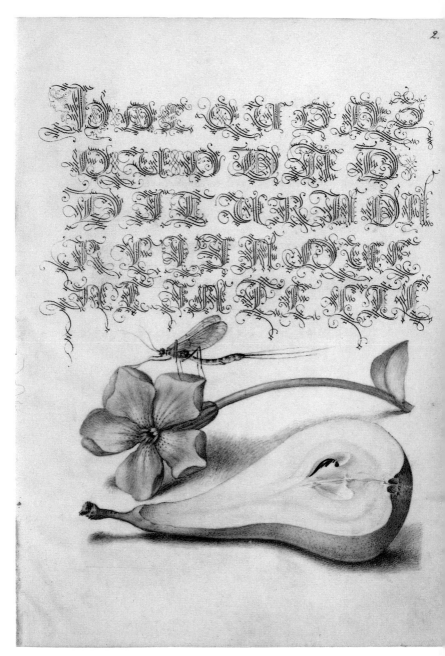

The Art of the Pen

CALLIGRAPHY
FROM THE COURT OF THE
EMPEROR RUDOLF II

Lee Hendrix and
Thea Vignau-Wilberg

THE J. PAUL GETTY MUSEUM
LOS ANGELES

The illustrations in this book have been selected from
Mira calligraphiae monumenta
first published by the J. Paul Getty Museum
and Thames & Hudson in 1992.
The texts have been adapted from
the same volume.

Christopher Hudson *Publisher*
Mark Greenberg *Editor in Chief*

On the front cover:
Folio 2. Decorated alphabet
Mayfly; Red campion (spotted petals unusual for species);
Common pear, gourd type

Introduction

THE MINIATURES reproduced here are from one of the most precious books of the European Renaissance, the *Mira calligraphiae monumenta* (the *Model Book of Calligraphy*) of Rudolf II. It is the work of two people who never actually met, and its origins are curious and complex.

In 1561–62 the master calligrapher Georg Bocskay, imperial secretary to the Holy Roman Emperor Ferdinand I, created a Model Book of Calligraphy, consisting of 129 folios and demonstrating a vast selection of contemporary and historical scripts. It was intended as proof of his own pre-eminence among scribes and was a work of exceptional visual splendor, being written on the finest white vellum and lavishly embellished with gold and silver. Bocskay was born in Croatia, then part of Hungary. Clearly an outstandingly gifted master of his art, he was a valued, and highly paid, member of the imperial court at Vienna, where he was described as 'scribe' and 'secretary' and 'court historian' and where his *Model Book of Calligraphy* was written. He also served Ferdinand's successor, Maximilian II, and died in 1575.

More than fifteen years after Bocskay's death, Ferdinand I's grandson, Emperor Rudolf II, commissioned Europe's last great illuminator, Joris Hoefnagel (1542–?1601), to illustrate the calligrapher's work. Hoefnagel was a man of immense learning and devised an ingenious figural response to Bocskay's scripts. Marshalling all the resources of pictorial illusionism, he sought to demonstrate the superior power of images over written words. His illuminations present a world of flowers, insects, fruit, small animals, and other forms of natural minutiae as extensive in its own way as Bocskay's collection of scripts.

The courts of Rudolf and his father, Maximilian II, were among the principal centers of sixteenth-century botany. It is clear that in his illuminations for the book Hoefnagel's project is part of the much more general attempt at court to amass and array knowledge, and particularly knowledge about the natural world. Emperor Rudolf II founded the vast and renowned collections which were housed at the imperial castle in Prague.

In the production of an illuminated manuscript, it was quite normal for the writing and the illuminations to be carried out by different people and for the writing to precede the illustrations. This division of labor contributed to the evolution of the manuscript page into a dynamic, compelling field from which image and text alike actively reached out to the viewer in an effort to communicate. However, the *Mira calligraphiae monumenta* marks something of a watershed in the traditional relation between the two elements, by constructing an explicit competition between them. Hoefnagel's decorative program in effect transformed Bocskay's original manuscript into a visual *paragone*, a kind of debate arguing the superiority of one art form over another.

Bocskay could not have anticipated the decorative program Hoefnagel devised. The illuminator's program hinged on the pre-existence of the script and his own capacity to formulate a witty and often satirical figural response to it. His illuminations consist of a diverse assemblage of natural specimens united by their small size.

The *Model Book of Calligraphy* stands at an art historical crossroad. It constitutes one of the last important monuments in the grand tradition of medieval European manuscript illumination.

In order to understand Bocskay's writing model book in the J. Paul Getty Museum, it is necessary to grasp the basic chronology of the emergence of calligraphy, or writing as a fine art, during the sixteenth century. One of the decisive factors in this chronology was the rise of printing, which displaced writing as the primary means of transmitting information.

During the Early Christian period and the Middle Ages, before printing arrived in Europe, writing emphasized the preservation of knowledge over its dissemination. Executed on vellum and often embellished with costly gold and silver, writing assumed great palpability and permanence. This was also expressed by the letter forms themselves, ranging from Carolingian minuscule (a classically based, upright, rounded lower-case script), with each individual letter carefully formed and separated from the next, to *textura* (upright, closely packed, Gothic blackletter), the thick, dark strokes of which lent words a physical presence on the page. The inseparability of a text from its physical embodiment in a finite number of codices contributed much to the resonance of the written word.

Also crucial to this development was the spread of writing, which ceased to be regarded primarily as the province of trained scribes and professionals and came to be valued as an essential humanistic accomplishment, expressive of one's intellectual background and social position. Just as an educated person was expected to be conversant in many languages, so he or she was required to have mastery over a corresponding number of script forms. Dominant among these was italic, or chancery, script. Rising to prominence during the late fifteenth century in Italy, where it became the favored script of the papal chancery in Rome,

italic was based on the clear, upright, round script known as humanist *antiqua*, which, when written quickly, became slanted, attenuated, and cursive. Italic effected the still uncontested wedding of Western handwriting to line. The kind of line required by italic emphasized dynamism, the impression of which was created by such qualities as thinness, consistency of width and tone, curvature, and minimal breaks.

In a curious turn of events, printing further contributed to the emergence of writing as an art form, since it was principally through the publication of model books that scribes became widely recognized as distinctive personalites. Among the earliest and most influential of such handwriting manuals were *Lo presente libro* by Giovannantonio Tagliente (Venice, 1524) and *La operina* by Ludovico degli Arrighi (Rome, 1522). Both were printed from woodblocks (engraved manuals becoming common only later in the century). Moreover, both were devoted principally to instruction in italic, which is indicative of the great cultural weight attached to classically inspired letter forms during the Renaissance. Yet, despite the pedagogical intent of their manuals and the classical clarity of italic as it was ideally conceived, neither Tagliente nor Arrighi could resist demonstrating their ability to exploit the aesthetic potential of italic script, the result of its singularly free and linear character. The publications of both scribes contain variations of classic chancery cursive in which lines are repeatedly drawn out to form webs of fluent ascenders, descenders, and serifs which hamper legibility.

With the publication of Giovanni Battista Palatino's *Libro nuovo d'imparare a scrivere* (Rome, 1540), the practical function of the writing manual gave way more dramatically than before to both the aesthetic potential of script and the force and personality of the scribe. The focus of Palatino's book remained chancery cursive,

and, as in earlier writing manuals, it included a full complement of practical scripts ranging from chancery alphabets to various mercantile and bastard (localized Gothic cursive) hands. Not content merely to equal the expertise of earlier authors, however, Palatino aimed for encyclopedic mastery of all writing, which he demonstrated by including an unusually large and inventive selection of indigenous and foreign hands as well as exhibition scripts such as florid Gothic letter types, mirror writing, and decorative alphabets.

Taking up the thread where Palatino's *Libro nuovo* left off, Georg Bocskay, in *Mira calligraphiae monumenta*, set out to assemble a collection of scripts of still greater immensity and to display unparalleled technical wizardry. Unlike the printed manuals, pedagogy plays no role in Bocskay's model book, which is intended solely as a display piece. The script forms are disposed according to no overarching order, thus underscoring the fact that the samples are not meant primarily to be read, but to be appreciated visually. Most of the texts are prayers, canticles, and psalms, but they also include imperial briefs and other forms of correspondence. The predominant type of script is italic. One finds a range of classic italic hands (fols. 19, 54, 61, 74) that are also furnished with an assortment of initials extending from florid examples written in gold to unadorned Roman capitals. Complementing such correct, restrained demonstrations of italic is the repertoire of flamboyant exhibition scripts to which italic gave rise, such as the examples of interlacing cursive, which are among the manuscript's most beguiling calligraphic demonstrations (fols. 34, 84, 98). Akin to this type are italic letters with exaggerated, interwoven ascenders and descenders (fols. 9, 22, 25, 36, 38, 82, 87). Satirizing the stress on linear continuity are two forms that also appear in Palatino's manual, "cut letters" (*lettere tagliate*), in which the upper and lower

halves of a line of script seem to be cut loose from one another (fols. 41, 96), and "scabby letters" (*lettere rognole*), in which protrusions break up the lines forming the letters (fols. 55, 93, 119). Backwards slant, a transgression in italic as it is normally written, becomes a source of amusement in numerous script samples (fol. 49).

Second in number to italic in Bocskay's model book are the various forms of *rotunda* (Italian Gothic) and *antiqua* (a classicizing humanist script based on Carolingian minuscule) which – because of their classical origins – were also employed as humanist hands (fols. 3, 45, 64, 77). These tend to be among the most sumptuous calligraphic specimens; the interstices between the lines of script are often filled with dense running vines in black, gold, and silver (fol. 108). Also common is an outlined *rotunda* known as "traced letters" (fol. 68), which are sometimes painted with dots of gold and blue. The classically based scripts include Roman inscriptional capitals as well (fols. 40, 63, 110).

The flowering of writing during the sixteenth century was fueled not only by the cultural idealism of the Renaissance humanists but also by the growing bureaucratic substructure in Europe, which required the services of ever larger numbers of secretaries. While italic became the principal secretarial hand in many countries, Gothic blackletter, which evolved into *Fraktur*, and Gothic chancery cursive remained dominant in Germany and the Holy Roman Empire, where they were also featured in writing manuals. As would be expected of a model book made for the emperor by an imperial scribe, Bocskay's codex contains a wide selection of Gothic scripts. Indeed, such a thoroughgoing synthesis of the traditions of Germanic and Italic writing manuals was achieved by no other scribe of the century.

The delicate German chancery cursive on folio 116 of Bocskay's book is based on a sample from the seminal German writing

manual *Eine gute Ordnung und kurzer Unterricht*, published by the famous writing master Johannes Neudörffer in Nuremberg in 1538. Among the most impressive and numerous samples of *Fraktur* are those from imperial briefs. Folios 105 and 129 represent two of the manuscript's five imposing black folios. Instead of vellum, they are paper, which was painted white, after which the letters appear to have been drawn in a clear substance resistive of the black ink wash applied over them. Other accomplished demonstrations of Germanic Gothic scripts are folios 11 and 117, salutations from Charles V and Ferdinand I, which feature magnificent swashed capitals composed of multiple strokes ending in extended flourishes.

Bocskay further substantiated his implicit claim to universal mastery of his art by a succession of historical, invented, and exhibition hands. Continuing a practice initiated by Tagliente of presenting ancient non-Roman scripts, Bocskay included samples of Greek and Hebrew, copying a Hebrew alphabet (fol. 35) from Palatino. There is also a range of Gothic scripts, such as the "bollatic" letters with their exuberantly flourishing ascenders and descenders (fols. 57, 67) and a sample (fol. 44) that resembles Tagliente's "French Gothic". Many of the scripts appear to be hybrids, such as the spiky Gothic capitals on folio 7 or that on folio 33, whose thick, black serifs and flourishes appear to have been inspired by mercantile hands. Bocskay, however, excluded pure mercantile and bastard scripts from his manuscript, presumably because the presence of business hands would have dulled the luster of his display piece.

Exhibition hands other than those already mentioned include decorated alphabets (fol. 2); "squared ciphers" (fol. 90) copied from Palatino; mirror writing in a variety of scripts (fols. 31, 49, 98); a calligram, or text picture whose shape or layout is determined

by its subject; diminished writing; and micrography, writing too small to be read with the naked eye. Displaying script at its greatest remove from conventional writing, exhibition hands epitomize the drive for virtuosity that dominated calligraphy by the end of the sixteenth century. This focus on virtuosity is in turn the most obvious manifestation of the effort to elevate writing to the status of a fine art that scribes appear to have undertaken in imitation of Renaissance visual artists. Unlike Arrighi, Tagliente, or Neudörffer, Bocskay was not a great formal innovator. Rather, his contribution to the art of writing lies in his transformation of it into a powerful medium for self-expression.

AD cœnam Agni prouidi et stolis albis Candidi: post transitum maris rubri Christo canamus Principi. Cuius corpus sanctissimum in Ara crucis torridum: cruore eius roseo gustando niuimus deo. Protecti paschæ uespere ac deuastante angelo: Erepti de durissimo Pharaonis Imperio. Iam pascha nostrū Christus est, qui immolatus agnus est: sinceritatis azyma, caro eius oblata est. O uere digna Hostia, per quàm fracta sunt tartara, redempta plebs captiuata reddita uitæ præmia. Cum surgit Christus tumulo, victor redit de barathro: tyrannum trudens uinculo et reserans paradisum. Quæsumus autor omnium in hoc paschali gaudio: ab omni mortis impetu tuum defende populum. Gloria tibi ꝛ cetꝫ.

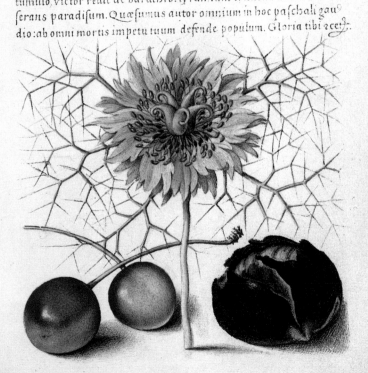

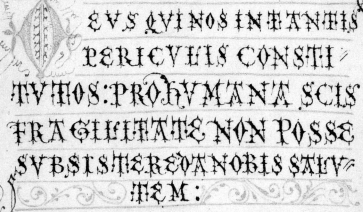

EVS QVI NOS IN TANTIS
PERICVLIS CONSTI-
TVTOS: PRO HVMANA SCIS
FRAGILITATE NON POSSE
SVBSISTERE DA NOBIS SALV-
TEM:

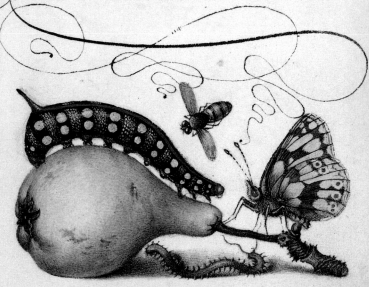

Nam gentem' super gentem Exurgere, ea Rumq; præ=
Iuram teRris in litteRe.pios iam in nostris tribulationibus Cer=
nimus, Quam in coDicibus legimus Quam te Rremotus
Vrbes inumeras subruat ex aliis munDi partibus,
citis, Quia frequenter auDimus pestilentiam

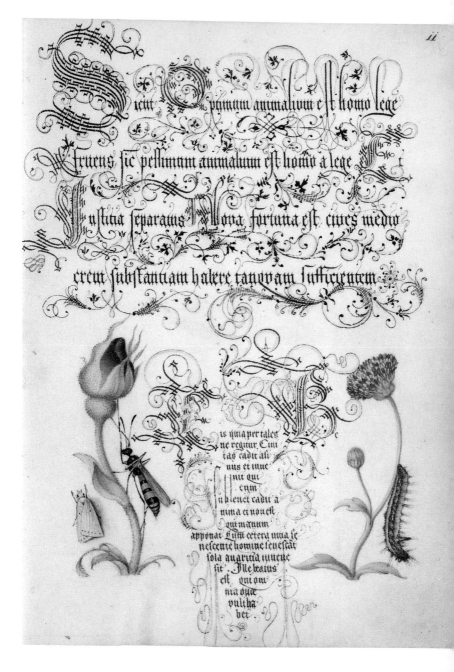

Sicut Optimum animalium est homo lege

utens, sic pessimum animalium est homo a lege

iustitia separatus: Nona fortuna est cives medio

cretu substantiam habere tanquam sufficientem

is iuria per tales
ne regitur. Cui
tas cadit ali
uus et inue
nit qui
eum
iu b i euet cadit a
nima et nouest
qui meruum
apponat Huiu cetera uina se
nescente homine senescat
sola auaricia iuuene
sit. Ille beatus
est qui om
nia quæ
uult ha
bet.

Deus qui Contritorum non despicis gemitum, et merentium non spernis affectum, adesto præcibus nostris, quas tibi pro tribulatione, nostra effundimus eas que clementer exaudi, ut quicquid contra nos diabolicæ, atque humanæ moliuntur aduersitates, ad nihilum redigatur et consilio tuæ pietatis allidatur, quatenus nullis aduersitatibus læsi, Sed de omni tribulatione, et angustia erepti, læti in ecclesia tua tibi gratias referamus. Dimitte peccata nostra domine, et tribue nobis misericordiam tuam, quàm præcamur, ut humilitatem nostram attendas, vincula soluas, delicta deleas, tribulationem Inspicias, aduersitatem repellas effectumque petitionis nostræ largiens supplices tuos Clementer exaudias, Amen

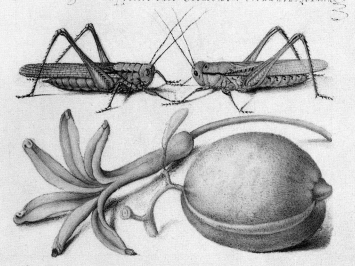

Ecce nunc benedicite dominum Omnes serui domini. Qui statis in do
mo domini: in atrus domus dei: in noctibus extollite manus uestras in sanc
ta. et benedicite dominum. Benedicat tibi dominus ex sion: qui fecit celum et terram. Ecce
qualem sententiam in die iudicii excipit, qui sine remedio penitentiæ ad festiuita
tem domini uitiorum sordibus inquinatus accesserit, in natali enim domini fratres cha
rissimi quasi in nuptys spiritualibus sponsæ suæ Ecclesiæ Christus adiunctus est. & cet.

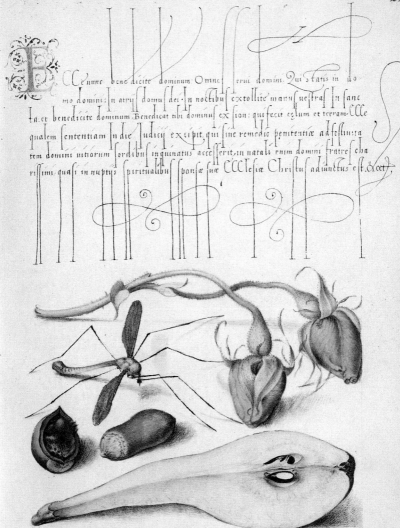

onne hic est qui tetri sedibus a Latinos vertice Inclinauit
vbiter liquidum humanis gressibus solidum preberet obsequium:
Et quid est quod ipse sibi sic maris denegat seruitutem vt breui
simul lacus transitum sub mercede Nauticha transfretaret Ascen
dit(inquit) in nauiculam, & transfretauit et quid mirum fratres
Christus benit suscipere Infirmitates nostras Et sua nobis confer
ret remedia Sanitatis: Quid medicus qui Non infert sanitatem

...res tuae pietatis Mitissime Deus
inclina precibus meis: Et grata fac
tibi spiritus illumina Cor meum: Vt in
is mysterijs digna ministrare: teque
æterna charitate diligere merear.
Deus qui tribus Pueris mitigasti flam=
mas Ignium: Concede propitius: ut
NOS famulos tuos Non exurat et

Est laus hodierni: trini dulcis annuo cives gaudio superni celebrant perpetuo, regem
trinum dum ter trini: chori laudant mutuo: vita melos cor supinum: trini cultus
munere veneremur regem trinum: voce votis opere: quem leo iubet masculinu
ter in anno colere. Singulari maiestati: decus et imperium: sacro sanctæ trini
tati: sit perenne, gaudium, in qua simus nos beati: per te christe præmium

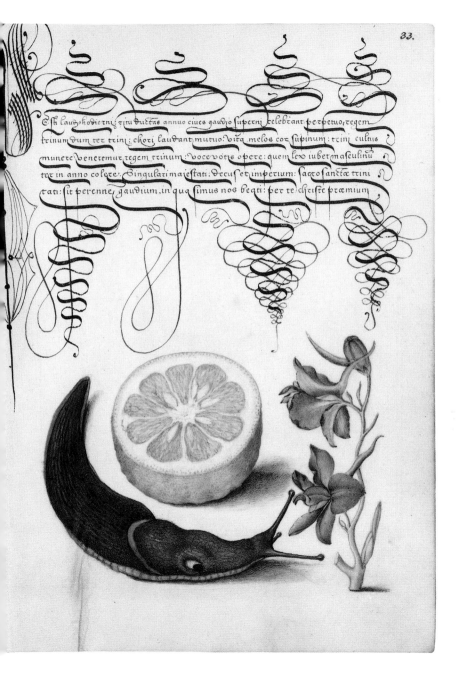

34.

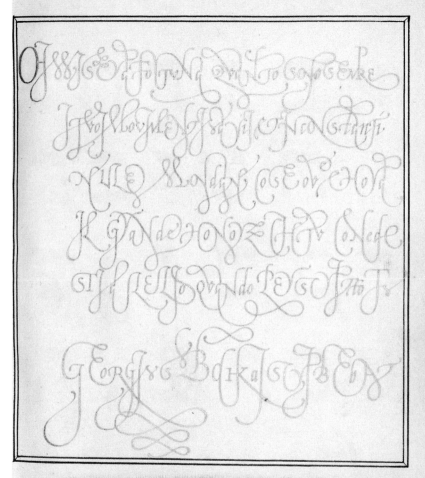

א ב ג ד ה ו

ז ח ט י כ ך

ל מ ם נ ן ס

ע פ ף צ ץ ק

ר ש ת

Inter veniat pro nobis quæsumus domine Iesu Christe, nunc, &
In hora Mortis nostre. Apud tuam clementiam Beata
Virgo Maria Mater tua cuius sacratissimam Animam in hora
Passionis tuæ doloris gladius pertransiuit, Per te, Iesu
Christe Saluator Mundi. Qui cum Patre viuis & Re
gnas per omnia sæcula sæculorum Amen & cætera

Pulchre autem relictis Judeis, habitaturus In affectibus gentium,
templum dominus ascendit. Hoc enim est templum verum: In
quo non In litera: Sed in spiritu dominus Adoratur. Hoc Dei
temmplum est: quod fidei series, non Lapidum structura fun
dauit. Deseruntur Ergo qui adorant: Eliguntur Qui ama
turi Erant. Et Ideo ad montem venit Oliueti: ut nouellas
Oliuas In sublimi virtutum plantaret: quarum Mater
Illa que sursum est Hierusalem: dominus mecum est.

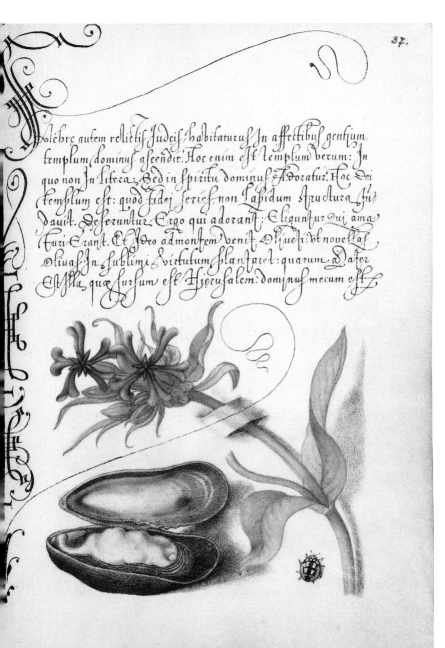

N hoc monte est ille cœlestis Agricola: vt Plantata omnes
in Domo Domini possunt in veritate dicere. Ego sicut Oli
ua fructificaui in Domo Domini. Et Fortasse, ipse Mons
est Christus. Quis enim alius tales fructus ferret olearum;
non curuescentium vbertate Baccarum: Sed spiritus pleni
tudine gentium fœcundarum. Ipse est per Quem Ascendi
mus: Et ad quem Ascendimus: ipse est Ianua: ipse
est via: Quæ aperitur: Et qui Aperit: quæ Pulsatur ab
ingredientibus, et Ab egredientibus Adoratur & cæterar

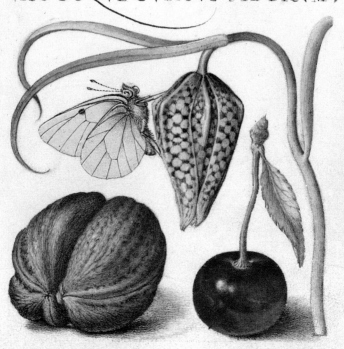

CELI DEVS SANCTISSIME
QVAM LVCIDVM CENTRVM PO-
LI CANDORE PINGIS IGNEO
AVGENS DE CORO LVMINI
QVARTO DIE QVI FLAMMA SO-
LIS ROTAM CONSTITVENS LV-
NÆ MINISTRANS ORDINEM
VAGOSQVE CVRSVS SYDERVM?

[Manuscript text in calligraphic Latin script — eight lines]

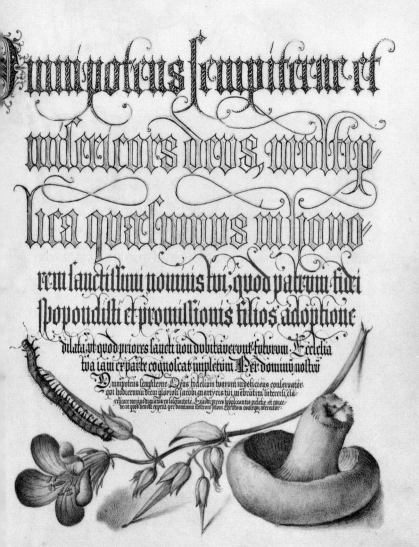

Omnipotens sempiterne et
misericors deus, multipli-
ca quaesumus in hono-
rem sanctissimi nominis tui, quod patrum fidei
spopondisti et promissionis filios adophione
dilata, ut quod priores sancti non dubitaverunt futurum, Ecclesia
tua iam ex parte cognoscat impletum. Per dominum nostrum
Omnipotens sempiterne Deus fidelium tuorum indeficiens conservator,
qui hodiernum diem gloriosi Iacobi martyris tui celebratim interesti, cla-
rificare omnia dignatus es solemnitate. Exaudi preces supplicantis ecclesiae, et conce-
de, ut quod devote expetit, per dominum nostrum Iesum Christum consequi mereatur

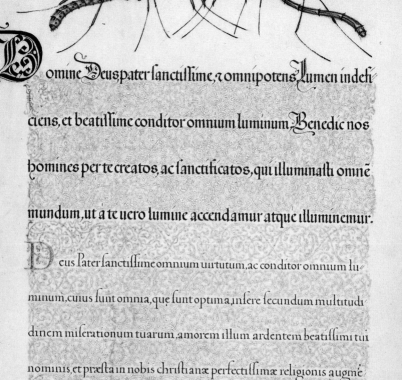

Domine Deus pater sanctissime, τ omnipotens Lumen indeficiens, et beatissime conditor omnium luminum. Benedic nos homines per te creatos, ac sanctificatos, qui illuminasti omnē mundum, ut a te uero lumine accendamur atque illuminemur.

Deus Pater sanctissime omnium uirtutum, ac conditor omnium luminum, cuius sunt omnia, quę sunt optima, insere secundum multitudinem miserationum tuarum, amorem illum ardentem beatissimi tui nominis, et præsta in nobis christianæ perfectissimæ religionis augmētum, ut tuo diuino auxilio nutriti, ad omnia pietatis studia accendaur.

namentum nobilium est Iudicina Vera Gratiatio Humilium, nobilium Virtus Nobilitas Ignobilium Pulchritudo Vilium Solamen maceran augmentum Pulchritudinum omnium Decus religionis Numeratio criminum multiplicatio meritorum Creatoris omnium Dei amica Ebrietas Vero est flagitiorum omnium culparumque mater, Radix omnium malorum ac criminum Origo Vitiorum turbatio capitis subuersio sensus Ignominiosus languor

naufragium castitatis amissio boni temporis tempestas linguae Insania voluntaria turpitudo morum bonestatis infamia animae corruptio la, Oratio vero est animi sancta præsidium Angelos sanctos solamen Diabolo supplicium gratum Deo obsequium et pænitentiæ laus toti

Radix ĝquidem est omnium malorū studium pecuniæ. Nam quicūque hominum ditelcere uolunt incidunt in temptationem et laquerim turpissimarum cupiditatum uehementer noxiarum, quia quidam dum appetunt, aberrauerunt a fide, et seiplos implicierunt coloribus multis. Tu uero homo Dei fuge ista, nam nihil intulimus in hunc mundum, indelicet nec efferre possumus, &c.

Grandissimo diletto gustano, se humane menti benignissimo lettore, nella dolce rimenbranza, delli santi precetti de antichi Philosophi, et delli preclarissimi fatti de inditti et fortisimi Jmper atori, Onde il gran stupore di natura et Principe di Peripatetici insegnaua ad Aless Maced: uolgere & riuolgere gli annali de la antichita, da quali sempre haueria per la sola mercede delli sacra ti augelli dello antico Pallamede, li quali a mal grado del tempo ne liberano dalla obliuione, di cose tan to degne et eccellenti, Desideroso caldamente dimonstrare alla Illu: & R:ma S. V. la affettione grandiss

Gratias ago immensæ Maiestati, ac sempiterne bonitati tue domine sancte Pater omnipo tens æterne Deus, qui me indignum famulum tuum et peccatorem miserum, nullis meis meis meritis, immo tuis multis et immensis exigentibus miserationibus, corpore et sangui ne domini nostri Jesu Christi fily tui dignatus es saturare, Præcor ut hec sacrosancta communi

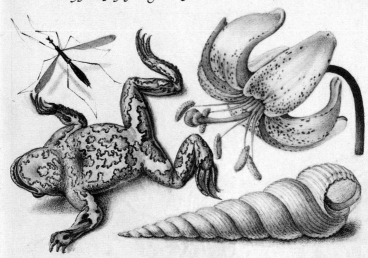

Imense cæli conditor: qui Mista ne confunderent: aquæ
fluenta dividens: cælum dedisti limitem firmans locu
cælestibus simulq Terræ rivulis: Ut vnda flam=
mas Temperet: terræ solum Ne dissipet: Infunde
nunc pyssime donum peremnis gloriæ fraudis novæ
ne casibus Nos error atterat vetus lucem fides
inveniat sic luminis Iubar ferat: Ut vana cuncta

Quæstus est magnus pietas, cum animo

sua forte contento. Nihil enim intu

limus in hunc mundum, videlicet

nec efferre quicquam possumus, sed

ncommodissimamente, ne soprauegnéde presenti contrarietas. Cu
auissimo et amicissimo mio Hieronymo ma difficilmente si possono
fuggire, tutti gli mouimenti della Instabilissima fortuna, conciosy
cosa, che gli humani prouedimenti scarsamente, ne suffragino, qua-
tunque nostra, se determim trauagliaten franc mio fratello, vsti
mamente. In sualicatee in campo, con perdita di cornilia.

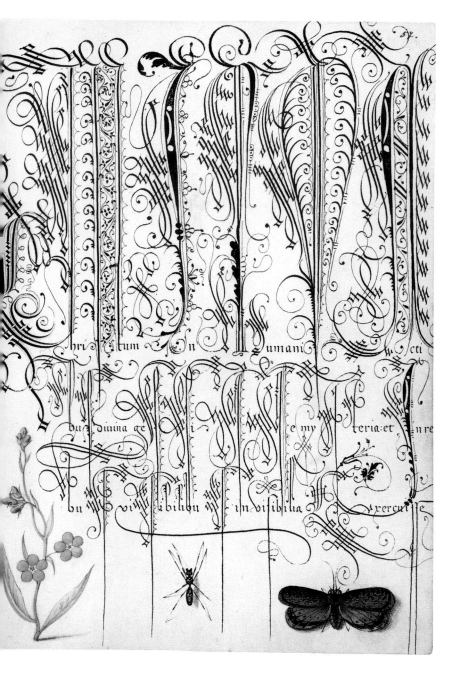

Ominus regnauit exultet terra: lœtentur Insulæ multæ. Nubes
& caligo incircuitu eius, iustitia et iudicium correctio sedis
eius. Ionis ante ipsum præcedet; & inflammabit in circui-
tu Spinicos eius. Alluxerunt fulgura eius orbi terræ; vidit, & commota
est terra. Montes sicut cera fluxerunt à facie domini; à facie domini om-
nis terra. Annuntiauerunt cœli iustitiam eius, & viderunt omnes populi
gloriam eius. Confundantur omnes gui adorant sculptilia: et gui gloriani-
tur in simulachris suis. Adorate eum omnes angeli eius; audiuit et lœta-
ta est sion; & exultauerunt filiæ iudæ propter iudicia tua domine. Quoni-
am tu dominus altissimus super omnem terram; nimis exaltatus es super
omnes deos. lœtamini iusti in domino; et confitemini memoriæ, &cetera &

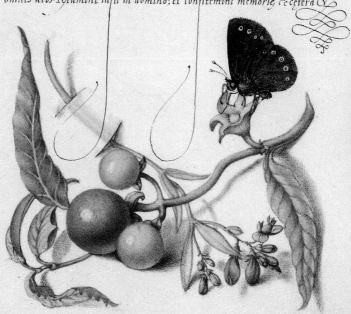

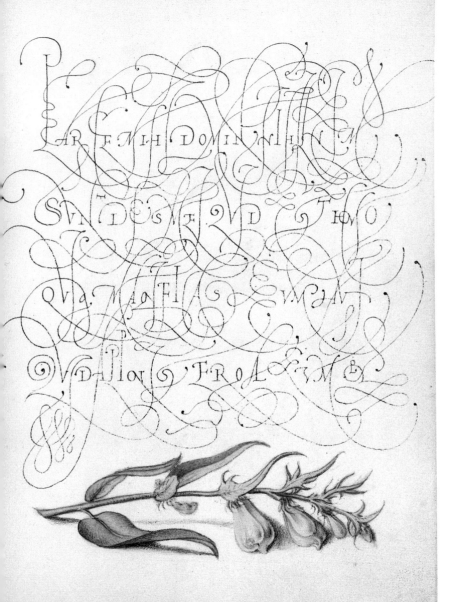

GRATIAM TVAM QVÆSVMVS DOMINE ME
NTIBVS NOSTRIS INFVNDE; VT QVI
ANGELO NVNTIANTE CHRISTI FILII
TVI INCARNATIONEM COGNOVIMVS PER
PASSIONEM EIVS ET CRVCEM AD RESVRRECTIO
NIS GLORIAM PERDVCAMVR PER DOMINVM
NOSTRVM IESVM CHRISTVM FILIVM TVVM
QVI TECVM VIVIT ET REGNAT IN VNITATE
STIRITVS SANCTI DEVS PER OMNIA SÆCV
LA SAECVLORVM AMEN,

QVI SE VLCISCITVR IN ILLO VLCISCETVR
SE DOMINVS ET PECCATA QVANDOQVE
EIVS RETINEBIT QVERVNT IN QST
PROPTER MANDATVM DEI

Impinguat caput oleum peccatoris, quum demulcet
mentem fauor adulantis. Qui de amore non ue
nit honor, non honor sed adulatio est. Opes im
piorum deficiunt, non aliter atque riuus ericca
tur. Qua mensura metimini, eadem remecietur
uobis

Nec cibus, sed omnia mala ab internis
procedentia coinquinant hominem.
Credimus te domine sed succur
re incredulitati nostre. Nam
omnis homo igne salietur
et omnis uictima salietur
si princeps aliquem e po
testate sua tradidit upo
nare uclit, prius
numebet facere
et non simul
totam po
testatem
auferre.

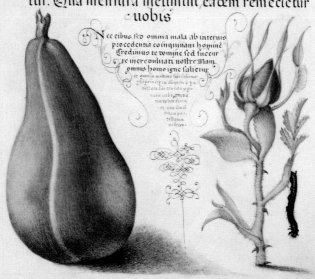

Lamaui in toto corde exaudi me Domine: iustificationes tuas re
quiram. Clamaui ad te saluum me fac: ut custodiam mandata
tua. Praeueni in maturitate et clamaui: quia in uerba tua sem
per speraui. Praeuenerunt oculi mei ad te diluculo: ut meditarer
eloquia tua. Vocem meam audi secundum misericordiam tuam Domine:
et secundum iudicium tuum uiuifica me. Appropinquauerunt persequen
tes me iniquitati: a lege autem tua longe facti sunt. Prope es tu Domine: et
omnes uiæ tuæ ueritas. Initio cognoui de testimonijs tuis: quia in æternü
fundasti ea. Vide humilitatem meam et eripe me domine: quia legem tuã
non sum oblitus. Iudica iudicium meum et redime me: propter eloquium
tuum uiuifica me. Longe a peccatoribus: salus: quia iustificationes tuas
non exquisierunt. Misericordiæ tuæ multæ Domine: secundum iudicium
tuum uiuifica me: Multi qui persequuntur me et tribulant me: a testimoni
ijs tuis non declinant. Vidi præuaricantes et tabescebam: quia eloquia tua
non custodierunt. Vide quoniam mandata tua dilexi Domine: in miseri
cordia tua uiuifica me. Principium uerborum tuorum ueritas in æternü
omnia iudicia iustitiæ tuæ.

Nemo bonus nisi vnus, nempe Deus Quicumquè
uoluerit ex uobis esse primus erit omnium
seruus. Necessitas amicitiam probat et in
timæ charitatis ardorem splendor ex

hibitæ subuentionis elucidat quantò minor in
passessione commoditas tantò minor in
Amissione dolor Nihil tam durum atq
ferruin, quod non amoris igne uincatur.

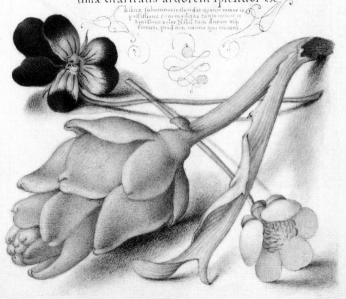

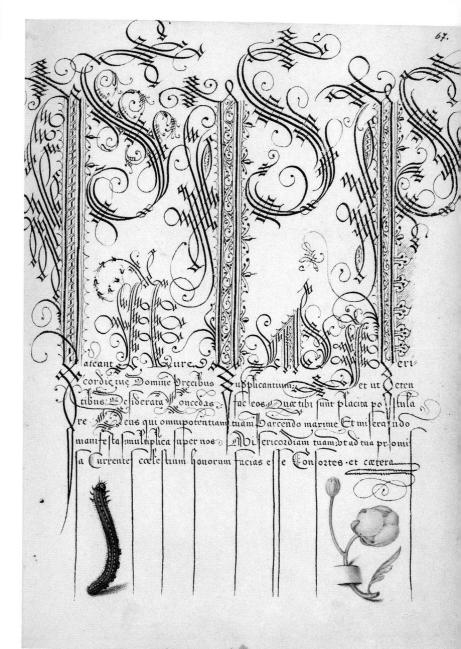

Pateant Aures misericordie tue Domine precibus Supplicantium et ut petentibus desiderata concedas fac eos Que tibi sunt placita postulare Deus qui omnipotentiam tuam parcendo maxime Et miserando manifesta multiplica super nos Misericordiam tuam vt ad tua promissa Currentes coelestium honorum facias esse Consortes et caetera

Acendit (inquit)in nauiculam et trans
fretauit, et quid mirum, fratres, Chri
stus venit suscipere Infirmitates nostras, et
sua nobis conferre remedia sanitatis;quia
medicus qui non infert sanitatem, Infirmi
tates curare nescit, et qui non fuerit cum
infirmo. Infirmatus infirmo non potest
conferre sanitatem, Christus ergo et c

Angulare fundamentum lapis christus missus: qui compage parietis in utroque nectitur: quem sion
sancta suscepit: in quo credens permanet:omnis illa deo sacra et dilecta ciuitas plena modulis in laude
et canere iubilo trinum deum ubicunque cum fauore praedicat. Hoc intento lumine deus exoratus
aduenit et clementi bonitate precum nota suscipe: largam benedictionem hic infunde iugiter: Hic praemerean
tur amaes pium acquirere: Quadepta possidere suum sanctus perenniter paradisum introire translati: In regnum
Aurora lucis rutilat, caelum laudibus intonat, mundus exultans iubilat: gemens infernus ululat, cum rex ille
fortissimus mortis confracta eis uiribus: pede conculcans tartara simul et poena miseros:illo quos clausus andre
custoditur sub milite tremunt:pompa nobili uictor surgit de funere. Solutis iam gemitibus, et inferni do
loribus quia surrexit dominus resplendens clamat angelus. et

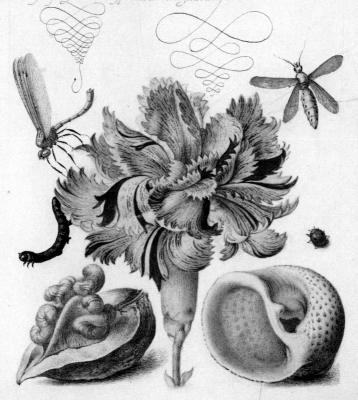

O Nimis Fælix Meritiq celsi: Nesciens labem niuei sudoris:
præpotens Martyr eremi: cultor maxime batum·Serta ter
denis alios Coronant Aucta crementis·duplicata quosdam:
trina centeno:cumulata fructu te sacer ornant·Nunc potens nostri
meritis Opimis pectoris duros lapides repelle: asperum planans
iter et Reflexos dirige calles vt pius mundi Fator et Redemptor
mentibus pulsa illusione putis: cite dignetur ueniens sacratos
ponere gressus Laudibus ciues celebrant superni te deus
simplex triniterque trine, supplices at Nos veniam precamur
parce Redemptis et Cæt.

quem chriſtus uiderit charitatis luce ueſtitum uſtitiæ vel

miſericordiæ margaritis ornatum:caſtum humilem:miſericordem

benignum,et ſobrium:ſi talem ſnuenerit uel agnouerit:corpuſ et an

quinem ſuum,et non ad ſudicium:ſed ad Remedium ſer ſacerdotum

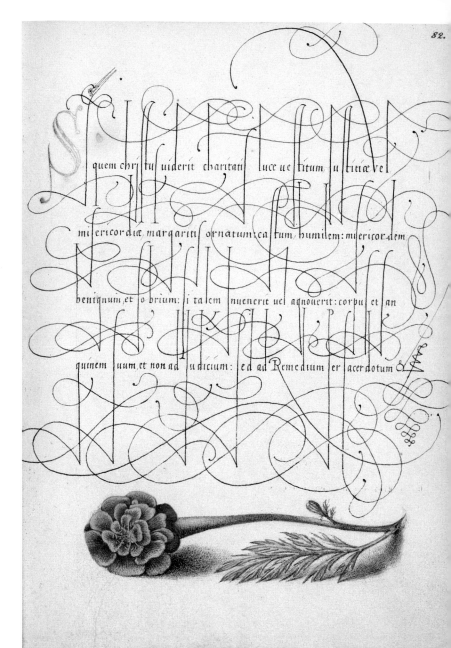

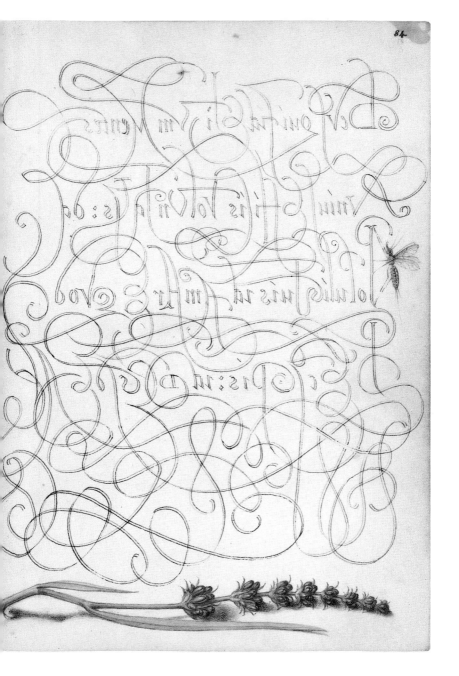

erba mea auribus percipe domine: intellige clamorem meum. Intende uoci Orationis
meæ: Rex meus, & deus meus: Quoniam ad te Orabo: mane Exaudies uocem me-
am. Mane astabo tibi et uidebo: quoniam non deus uolens iniquitatem tu es. Neque
habitabit iuxta te malignus: neque permanebunt iniusti ante oculos tuos. odisti omnes
qui operantur iniquitatem: perdes omnes qui loquuntur mendatium: uirum sanguinū
et dolosum, abominabitur dominus: ego autem in multitudine misericordiæ tuæ. Introibo
in domum tuam: adorabo ad templum sanctum tuum in timore tuo. Domine deduc me
in iustitia tua propter Inimicos meos: dirige in conspectu tuo uiam meam. Quoniam non
est in ore eorum ueritas: cor eorum uanum est. Sepulchrum patens est guttur eorum: linguis
suis dolose agebant: iudica illos deus. Decidant à cogitationibus suis: secundum multitudinem

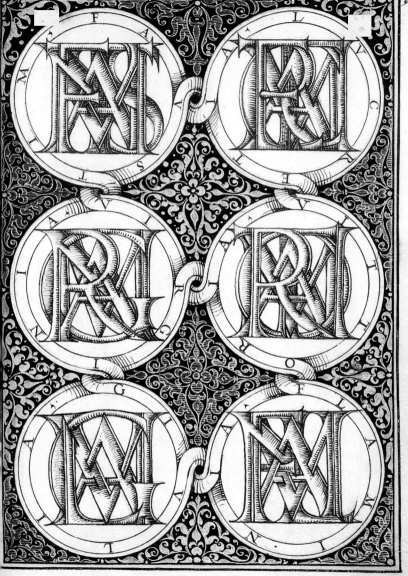

Domine ne in furore tuo arguas me

neque in ira tua corripias me. Quoni

am sagitte tue infixe sunt mihi et con

firmasti super me manum tuam. Non

est sanitas in carne mea a facie ire tue

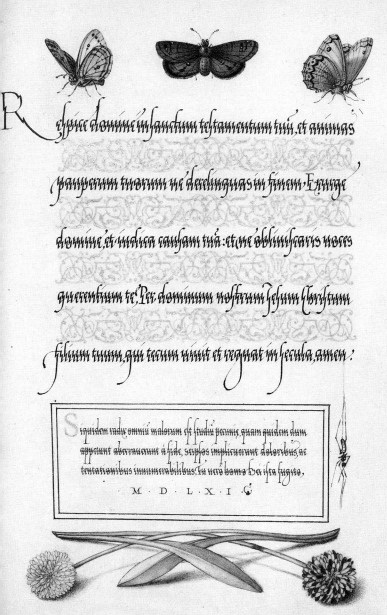

Respice domine in sanctum testamentum tuum, et animas

pauperum tuorum ne derelinquas in finem. Exurge

domine, et iudica causam tuam: et ne obliviscaris voces

querentium te. Per dominum nostrum Iesum Christum

filium tuum, qui tecum vivit et regnat in secula, amen.

Siquidem radix omnium malorum est studium pecunie, quam quidem dum
appetunt aberraverunt à fide, seipsos impliciuerunt doloribus, ac
tentationibus innumerabilibus. Tu vero homo Dei ista fugito.

· M · D · L · X · I · C ·

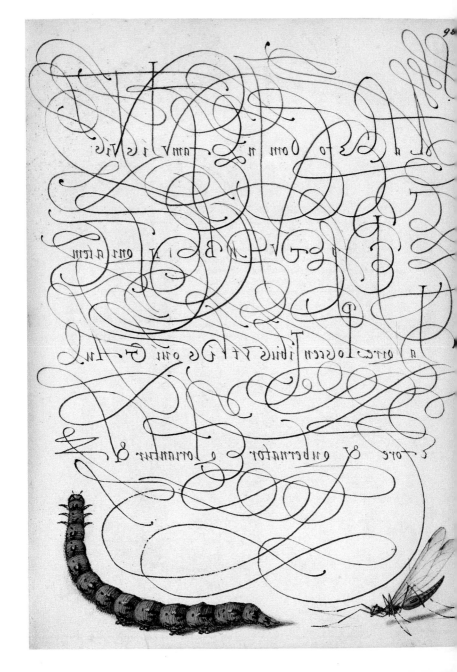

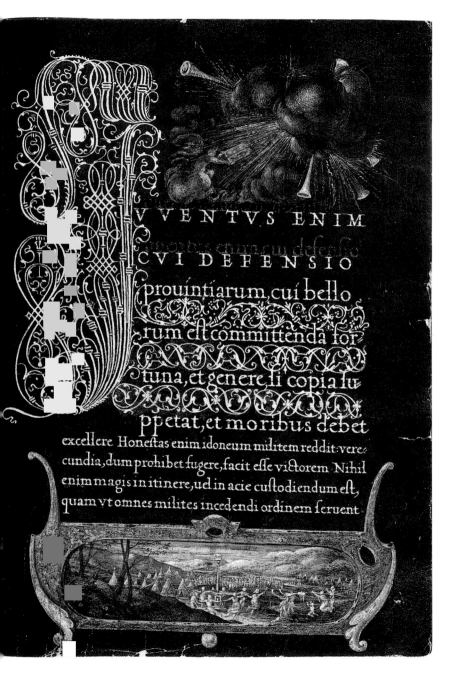

IVVENTVS ENIM

iuuentus enim cui defensio

CVI DEFENSIO
prouintiarum, cui bello
rum est committenda for
tuna, et genere, si copia su
ppetat, et moribus debet
excellere Honestas enim idoneum militem reddit: vere=
cundia, dum prohibet fugere, facit esse victorem. Nihil
enim magis in itinere, uel in acie custodiendum est,
quam vt omnes milites incedendi ordinem seruent.

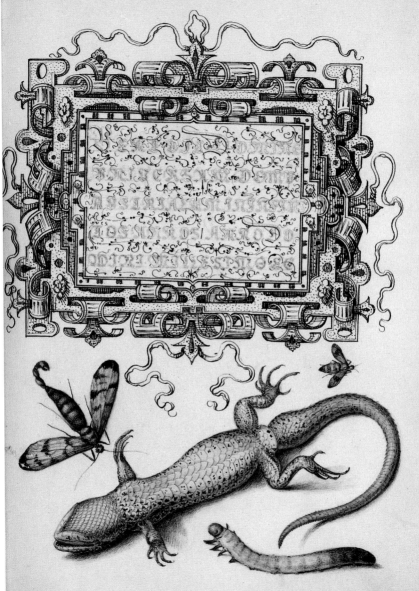

SICVT SVMENDA SVNT AMARA SALVBRIA
ITA SEMPER VITANDA PERNICIOSA T
DVICEDO · HOLOCAVSTVM IVSTI ALTARE ORNAT
ET DITAT, ET ODOR SVAVISSIMVS EST CORAM
ALTISSIMO, AMEN DICO VOBIS, QVATENVS FE
CISTIS VNI DE HIS FRATRIBVS MEIS MINIMIS,
MIHI FECISTIS. EMOLIRI ADVLATIONIBVS NON
SOLVM FORTITVDINIS NON ESSE SED ETIAM IGNA
VIAE · VIDETVR · NOS AD PATRIAM FESTINANTES,
MORTIFEROS SIRENARVM CANTVS SVRDA AV
RE TRANSIRE DEBEMVS ·

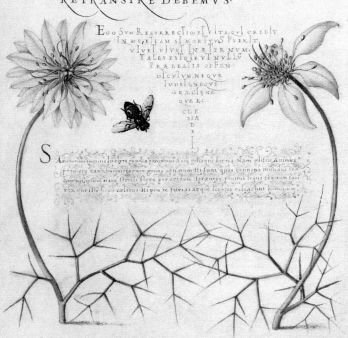

EGO SVM RESVRRECTIO ET VITA QVI CREDIT
IN ME, ETIAM SI MORTVVS FVERIT
VIVET VIVET IN AETERNVM
TALES ESTOTE VT NVLLV
PRAEBEATIS OFFEN
DICVLVM NEQVE
IVDEIS NEQVE
GRAECISNE
QVE EC
CLE
SIAE
DE
I

S Anteorum meritis incluta gaudia pangamus Sed gestaque fortia. Nam gestis Animus
proinceps canibus interitum genus optimum Hi sunt quos retinens minibus in
Haeret, ipsum nam Oculis flere per aethum spernere penitus itaque sequuntur sunt
rex Christe bene exititus Hi pro te furias atque ferocia calcarint hominum.

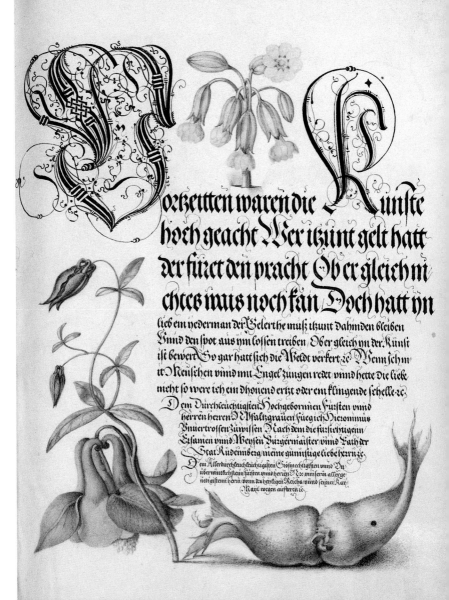

orzeitten waren die Kunste
hoch geacht Wer itzunt gelt hatt
der füret den pracht Ob er gleich ni
chtes auß noch kan Doch hatt yn
lieb ein yederman der Gelerthe muß itzunt dahinden bleiben
Vnnd den spot aus ym lossen treiben Ob er gleich yn der Kunst
ist bewert So gar hatt sich die Weldt verkert. ⁊c Wenn ich mi
t Menschen vnnd mit Engel zungen redt vnnd hette die liebe
nicht so were ich ein dhonend ertzt oder ein klingende schelle ⁊c

Dem Durchleüchtigsten Hochgebornnen Fürsten vnnd
herren herren N Pfaltzgrauen fueg ich Hieronimus
Bnuertrossen zuwissen Nach dem die fürsichtigenn
Ersamen vnnd Weysen Burgermaister vnnd Rath der
Stat Kudennberg meine günnstige liebe herrn ⁊c

Dem Allerdurchleuchtigsten Grosmechtigsten vnnd Vn
 überwintlichstenn fürsten vnnd herrenn ⁊c mmserin allerge
nedigistemi herrin vonn des hevtligen Reichs vnnd seyner Kay:
Mayt wegen aufkeren ⁊c

Magnificat anima mea dominum. Et exultauit spiritus meus in deo salutari meo.

Quia respexit humilitatem ancillae suae ecce ex hoc beatam me dicent omnes generationes. Quia fecit mihi

magna qui potens est, et sanctum nomen eius. Et misericordia eius a progenie in progenies timentibus eum.

Fecit potentiam in brachio suo disperssit superbos mente cordis sui. Deposuit potentes de sede et exaltauit humiles.

Esurientes impleuit bonis et diuites dimisit inanes. Suscepit israel puerum suum recordatus misericordiae suae. Sicut locutus est ad patres nostros, Abraham et

semini eius in secula. Gloria patri et filio et spiritui sancto. Sicut erat in principio et nunc et semper et in

secula seculorum amen. Gloria patri et filio et spiritui sancto. Anno domini Millesimo 1562.

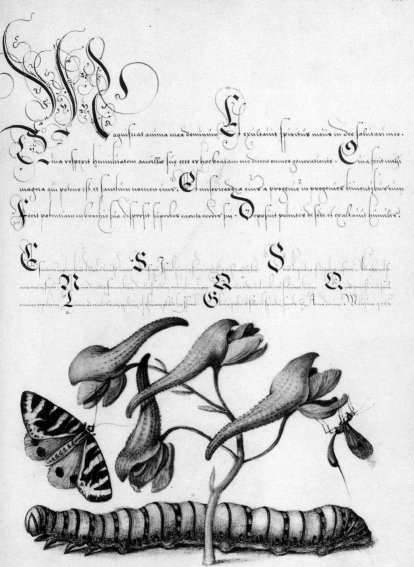

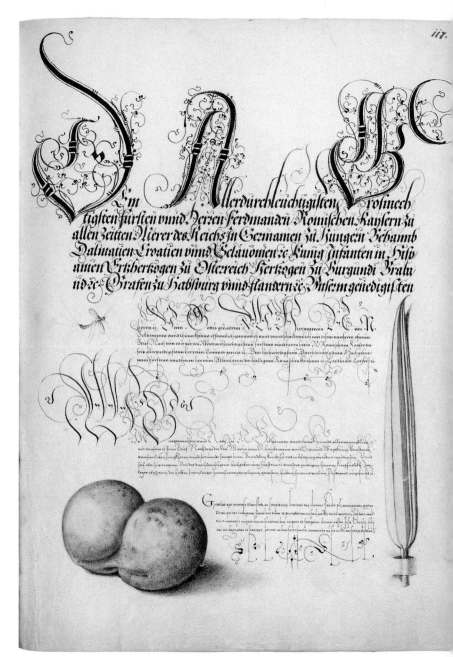

Dem Allerdurchleuchtigisten Großmechtigisten fürsten vnnd, herren ferdinanden Römischen Kaysern zu allen Zeitten Merer des Reichs in Germanien zu Hungern Behaimb Dalmatien Croatien vnnd Sclauonien zc Kunig Infanten in Hispanien Erthertzogen zu Österreich Hertzogen zu Burgundi Brabandt zc Grafen zu Habsburg vnnd flandern zc. Vnserm genedigisten

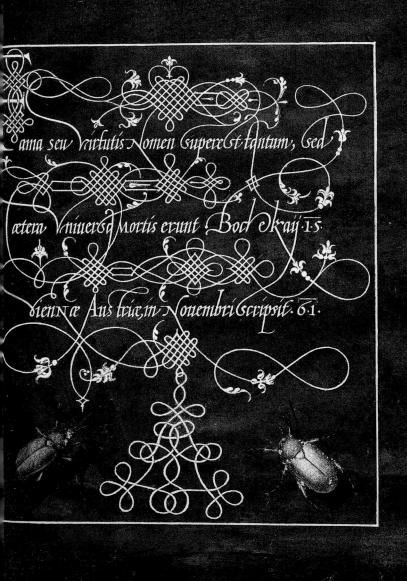

ama seu virtutis Nomen superest tantum, sed

cætera Vniuersa Mortis erunt Boch Ekaÿ·15·

bienNæ Aus triæ, in Nouembri scripsit. 6̄1.

OMNIPOTENS

...tüm bonorum nobis subsidia tribuas et futura Per dominum nostrum Jesum Christum filium tuum. &c Anno dom. millesimo quingentesimo, sexagesimo primo, Georgius Bochkai de Razinia, Hungarus qui supra manu propria scripsit. Vienne

Deus bonorum omnium remunerator est Consilium est examinandarum gubernandarumque causarum subtilissimus animi prospectus Anno M.D.LXI.

PLATES

The identifications of specimens proceed from top to bottom and from left to right. Common names have been provided wherever possible. In the case of the insect identifications, British English common names have ben used, since most of the specimens represented do not exist in the United States. Where a different American common name is known, it has been included following the British name, separated by a slash. The names of higher taxonomic groups (families and orders) have been printed in roman type, *while genus and species names appear in italic.*

Frontispiece. FOLIO 2. Decorated alphabet
Ephemeroptera: Mayfly
Silene Dioica (L.)Clairv.: Red campion (spotted petals unusual for species)
Pyrus communis L.: Common pear, gourd type

FOLIO 3. *Antiqua* script
Nigella damascena L. "Plena": Love-in-a-mist
Prunus avium (L.) L.: Sweet cherry
Castanea sativa Mill.: Spanish chestnut

FOLIO 7. Gothic capitals
Diptera Syrphidae (?): Hover fly/flower fly
Lepidoptera Sphingidae *Hyles euphorbiae* (L.): Horntail caterpillar of spurge hawk-moth
Pyrus communis L.: Common pear, gourd type
Lep. Satyridae *Melanargia galathea* ssp.

galathea (L.): Marbled white
Chilopoda: Centipede

FOLIO 9. Letters with exaggerated ascenders and descenders
Arachnida Araneae Pisauridae *Dolmedes fimbriata* (Clerck): Nurseryweb spider
Nigella damascena L.: Love-in-a-mist
Hymenoptera Eumenidae *Eumenes* sp.: Potter wasp
Ribes Rubrum L.: Red currant

FOLIO 11. Germanic Gothic script with decorated initial
Lepidoptera Noctuidae *Mythimna straminea* (Treitschke) or *M. obsoleta* (Hübner): Southern or obscure wainscot
Rosa gallica L.: French rose, bud
Imaginary wasplike insect
Bellis perennis L. "Hortensis": English daisy
Lep. Lasiocampidae: Caterpillar of lasiocampid moth (?)

FOLIO 19. Classic italic hand
Orthoptera Tettigoniidae: Wart-
 biter (?)
Decticus verrucivorus (L.) (?) Orth.:
 Grasshopper (characteristics of
 Acrididae and Tettigoniidae)
Hyacinthus orientalis L.: Hyacinth,
 single flower
Prunus dulcis (Mill.) D. A.Webb.:
 Almond

FOLIO 22. Italic letters
 with exaggerated ascenders and
 descenders and illuminated capital
Rosa gallica L.: French rose
Diptera Tipulidae: Crane fly
Corylus avellana L.: European filbert
Pyrus communis L.: Common pear,
 gourd type

FOLIO 25. Italic letters
 with exaggerated ascenders and
 descenders
Imaginary insect
Tulipa gesneriana L.: Tulip, striped
 pink/white/yellow
Unidentifiable caterpillar
Arachnida Araneae: Spider
Pyrus communis L.: Common pear,
 round type

FOLIO 31. Reversed italic script
 with illuminated initial
Phaseolus vulgaris L.: Kidney bean
Anemone coronaria L.: Poppy anemone
Vipera berus (?): Adder

FOLIO 33. Hybrid script inspired
 by mercantile hand

Citrus aurantium L.: Sour orange
Pulmonata Arionidae *Arion* cf. *rufus*
 (L.): Terrestrial mollusk
Consolida regalis S. F. Gray: Larkspur

FOLIO 34. Interlacing cursive
Lepidoptera Lasiocampidae
 Lasiocampa quercus (L.): Larva of
 oak egger moth

FOLIO 35. Hebrew alphabet

FOLIO 36. Italic letters with
 exaggerated ascenders and
 descenders
Matthiola incana (L.) R. Br.:
 Gillyflower
Imaginary insect
Veronica chamaedrys L.: Germander
Prunus dulcis (Mill.) D. A. Webb:
 Almond
Rana (*temporaria* [?]): Common frog

FOLIO 37. Italic script
Lychnis chalcedonica L.: Maltese cross
Bivalvia Mytilidae *Mytilus edulis* (L.):
 European edible mussel
Coleoptera Coccinellidae *Propylaea
 quatuordecimpunctata* (L.) or *Adalia
 decempunctata* (L.) var. : Fourteen-
 or ten-spot ladybird (inaccurate
 color pattern; eight legs shown
 instead of six)

FOLIO 38. Italic letters
 with exaggerated ascenders and
 descenders
Viola odorata L.: Sweet violet
Curcurbita pepo L.: Gourd

Erythronium dens-canis L.: Dog-tooth violet

FOLIO 40. Backward-slanting Roman capitals
Lepidoptera Pieridae and Papilionidae, elements of *Aporia crataegi* (L.) and *Parnassius mnemosyne* (L.): Imaginary butterfly (elements of black-veined white and clouded apollo)
Fritillaria meleagris L.: Snakeshead
Juglans regia L.: English walnut
Prunus avium (L.) L.: Sweet cherry

FOLIO 41. "Cut letters" (*lettere tagliate*) with flourished initial
Phalaris arundinacea L. "Picta": Reed grass
Rosa gallica L.: French rose
Bufo (*bufo* [?]): Common toad
Matthiola incana (L.) R. Br.: Gillyflower

FOLIO 44. French Gothic illuminated letters
Chilopoda: Centipede
Geranium sylvaticum L.: Wood cranesbill
Unidentifiable mushroom

FOLIO 45. *Antiqua* script
Diptera Tipulidae *Ctenophora atrata* (L.) or related species: : Male crested crane fly (inaccurate venation; characteristic shape and antennae)
Dipt. Tipulidae: Imaginary insect

(resembles crane fly; four wings shown instead of two)
Rosa gallica L.: French rose

FOLIO 49. Backward-slanting italic script
Colutea arborescens L.: Bladder senna
Scilla bifolia L.: Alpine squill

FOLIO 50. Two versions of italic script
Heteroptera Hydrometridae *Hydrometra stagnorum* L. or *gracilenta* Horv.: Water gnat/water measurer (eyes too far forward on head)
Lilium martagon L. "Album": Martagon lily
Bombina variegata: Yellow-bellied toad, ventral view
Prosobranchia Turritellidae *Turritella communis* Risso: European screw shell

FOLIO 54. Italic script
Vitis vinifera L.: Wine grape
Matthiola incana (L.) R. Br.: Gillyflower
Pulmonata Helicidae: Imaginary land snail (derived from *Cepaea* sp. [?]) sinistral (left wound)

FOLIO 55. "Scabby letters" (*lettere rognole*) and italic letters with exaggerated ascenders and descenders
Lepidoptera Sphingidae: Resembles (horntail) caterpillar of *Agrius* (= *Herse*) *convolvuli* (L.)

(convolvulus hawk-moth)

Lep. Sphingidae: Horntail caterpillar of *Macroglossum stellatarum* (L.) (hummingbird hawk-moth) (?)

FOLIO 57. "Bollatic" letters with flourished ascenders and descenders

Omphalodes verna Moench: Creeping forget-me-not

Homoptera Berytinidae (?): Imaginary eight-legged insect (Hymenoptera-like abdomen; resembles superficially larva of *Neides tipularis* [L.], species of "stilt bug")

Homoptera Flatidae: Flatid planthopper (?) (species does not occur in Europe)

FOLIO 61. Italic script with decorated initial

Lepidoptera Satyridae *Aphantopus hyperantus* (L.): Ringlet (dots on undersides of wings do not match this or related species)

Solanum pseudocapsicum L.: False Jerusalem cherry

Polygala vulgaris L.: Common milkwort

FOLIO 62. Flourished Roman capitals

Melampyrum pratense L.: Common cow-wheat

FOLIO 63. Roman capitals and *Antiqua* script

Pyrus communis L.: Common pear

Rosa gallica L.: French rose

Lepidoptera: Unidentifiable caterpillar

FOLIO 64. Two sizes of *Antiqua* script with decorated capitals

Viola tricolor L.: European wild pansy

Cynara scolymus L. *Ranunculus* sp.: Artichoke

FOLIO 67. "Bollatic" letters with flourished ascenders and descenders

Lepidoptera: Unidentifiable caterpillar

Trollius europaeus L.: Globeflower

FOLIO 68. Italic script in "traced letters" with illuminated initial

Odonata Zygoptera: Unidentifiable damselfly

Dianthus caryophyllus L.: Carnation

Heteroptera Pyrrhocoridae: Derived from *Pyrrhocris apterus* (L.) (common firebug) (?)

Lepidoptera Lasiocampidae: Caterpillar (resembles superficially *Philudoria potatoria* [L.] [drinker]; *Lasiocampa quercus* [L] [larva of egger moth] [?])

Cornus mas L.: Carnelian cherry, in fruit

Chilopoda: Centipede

FOLIO 74. Italic script

Odonata Zygoptera: Imaginary damselfly

Dianthus caryophyllus L.: Carnation
Imaginary insect
Lepidoptera: Unidentifiable
 caterpillar
Coleoptera Coccinellidae *Adalia
 bipunctata* (L.): Two-spot
 ladybird/two-spotted lady beetle
Juglans regia L.: English walnut
Prosbranchia Naticidae *Naticarius
 millepunctatus* (Lamark): Marine
 mollusk

FOLIO 77. *Antiqua* script
Hymenoptera Ichneumonidae:
 Imaginary "hymenopterous"
 "ichneumonfly-type" insect
Juglans regia L.: English walnut
Hypericum maculatum Crantz:
 Imperforate Saint John's wort
Crustacea Decapoda: Crayfish

FOLIO 82. Italic script
 with exaggerated ascenders and
 descenders
Tagetes patula L.: French marigold

FOLIO 84. Reversed "traced" script
Imaginary insect
Hyssopus officinalis L.: Hyssop

FOLIO 87. Italic script
 with exaggerated ascenders and
 descenders
Campanula rapunculus L.: Rampion
Dictamnus albus L.: Dittany
Pyrus communis L.: Common pear

FOLIO 90. "Squared ciphers" with
 superimposed letters spelling the
names of illustrious women of
 ancient Rome

FOLIO 93. "Scabby letters" (*lettere
 rognole*)
Crocus augustifolius Weston: Cloth-of-
 gold crocus
Coleoptera: Unidentifiable beetle
Digitalis purpurea L.: Common
 foxglove

FOLIO 96. "Cut letters" (*lettere
 tagliate*)
Lepidoptera: Three imaginary
 lepidopterans (two imaginary
 butterflies; one imaginary moth
 with butterfly antennae)
Arachnida Araneae: Spider
Bellis perennis L. "Hortensis":
 English daisy, two flowers

FOLIO 98. Flourished mirror script
Lepidoptera: Imaginary caterpillar
 (inaccurately placed abdominal
 legs)
Imaginary insect

FOLIO 105. Black folio. *Antiqua*
 script with decorated initial
Moses Receiving the Ten
 Commandments. The Israelites
 Dancing around the Golden Calf

FOLIO 108. Hybrid Gothic script
 with running vines
Mecoptera Panorpidae *Panorpa
 communi*s (L.) or other *Panorpa* sp.:
 Common scorpionfly (?), male
Imaginary insect

Lacerta vivipara (?): Viviparous lizard, ventral view

Hymenoptera Tenthredinidae (?): Unidentifiable insect larva (sawfly larva [?])

FOLIO 110. Roman inscriptional capitals

Nigella sativa L.: Black cumin, double flower

Imaginary Hymenoptera-like insect

Nigella sativa L.: Black cumin, single flower

FOLIO 111. Gothic script with ornamented initial

Primula veris L.: Cowslip

Aquilegia vulgaris L.: European columbine

Corylus maxima Mill. once infested with *Curculio nucum* L. (Coleoptera Curculionidae): Giant filbert; hazelnut weevil

FOLIO 116. German chancery cursive with ornamented initial

Lepidoptera Arctiidae *Callimorpha dominula* (L.): Scarlet tiger-moth

Consolida regalis S. F. Gray: Larkspur

Imaginary icneumonfly-like insect

Lep. Papilionidae or Saturnidae: Imaginary caterpillar (based on *Papilio machaon* L. [swallowtail] or mature larva of *Saturnia pavonia* L. [emperor moth] [?]; colors and structure different from both; inaccurately placed legs)

FOLIO 117. Sloped German Gothic with ornamented initials

Ephemeroptera (?): Mayfly (?)

Prunus armeniaca L. (?): Apricot, fruits grown together

Phalaris arundinacea L. "Picta": Reed grass

FOLIO 129. Black folio. Italic script with exaggerated flourishes

Coleoptera Carabidae: Ground beetle(?) (inaccurate dimensions)

Col. Scarabaeidae *Anomala dubia* (Scop.): Scarab

FOLIO 119. "Scabby letters" (*lettere rognole*) with ornamented initial

Odonata Zygoptera: Two imaginary damselflies